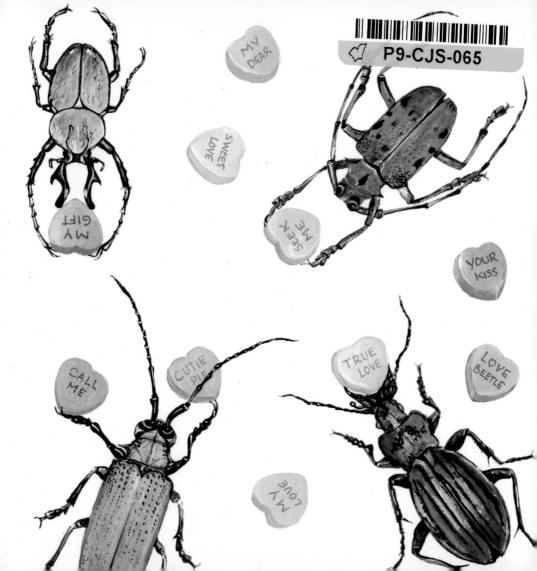

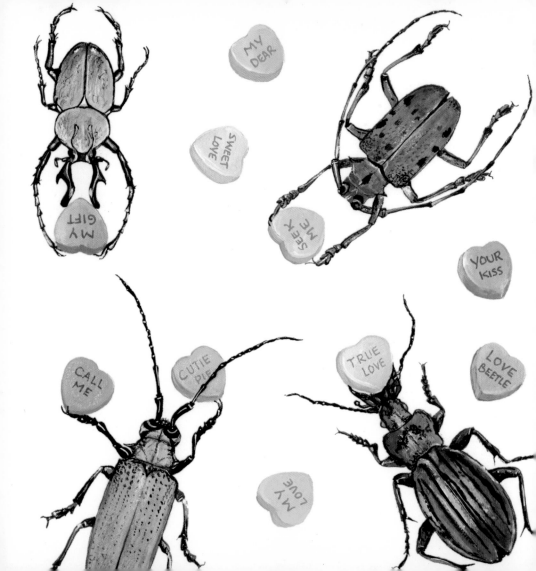

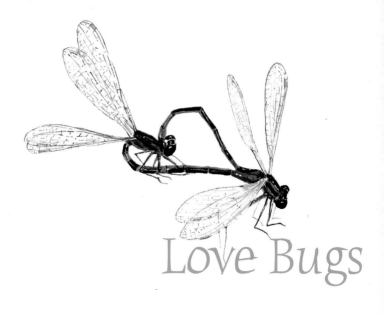

Love Bugs

Maryjo Koch

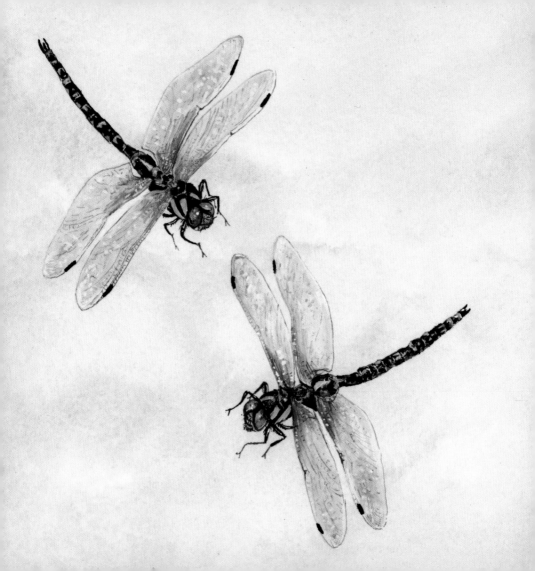

Love Bugs

A Bug-Eyed View of Romance

Maryjo Koch

**Andrews McMeel
Publishing, LLC**

Kansas City • Sydney • London

Concept and Design: Jennifer Barry Design, Fairfax, California
Production Assistance: Kristen Hall

10 11 12 13 14 WKT 10 9 8 7 6 5 4 3 2 1

ISBN: 978-0-7407-9784-2

Library of Congress Control Number:
2010924499

www.andrewsmcmeel.com

Attention: Schools and Businesses
Andrews McMeel books are available at quantity discounts with bulk purchase for educational, business, or sales promotional use. For information, please write to:
Special Sales Department, Andrews McMeel Publishing, LLC, 1130 Walnut Street, Kansas City, Missouri 64106.

I am always amazed by the astonishing beauty of insects. Their bright colors and fascinating forms intrigue me; from fuzzy bees to metallic beetles, they are the living jewels of the natural world. I want to paint them the instant I see them. Trying to find the right colors of paints to match their colors, or to catch their iridescence, is a challenge and a delight.

I love to observe the insects in my garden. Watching ladybugs devour the aphids on my fava bean plants, I want to cheer them on. The bees work so hard at pollinating, along with the bumblebees and hummingbirds. And watching an adult insect emerge from a pupa and turn into a beautiful butterfly right before my eyes is magical.

We share our world with an amazing number of insects; they make up more than half of all the species on earth. They have evolved, along with flowering plants, in a myriad of ways to adapt to every kind of habitat on our planet, and to play an essential role in its existence. Without insects, life on earth as it is today would cease.

Just as we need insects, male and female insects need each other. Their major role is to reproduce so that their species can continue to be part of the web of life. Every species has developed a different way for males and females to find and attract each other, and insect courtship rituals include perfume, gifts, songs, dances, and preening. When we look closely at the varied colors, shapes, and behaviors of these tiny creatures, we can see how rich and intricate life on earth really is, and how we are all linked to one another.

—Maryjo Koch

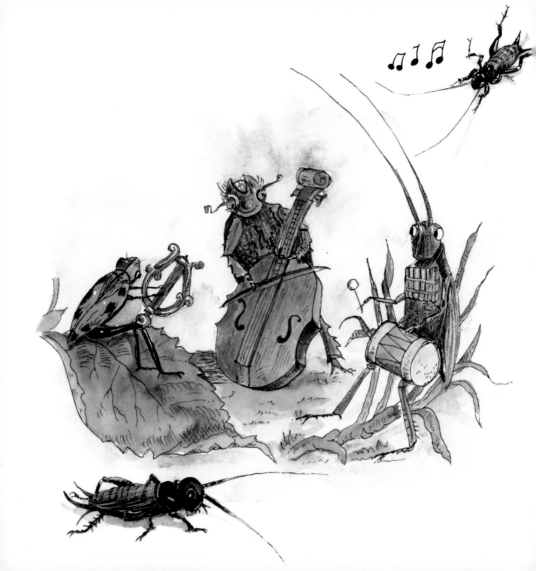

Being in love
is like
friendship set to
music.

To love
is to join your
happiness to the
happiness of
another.

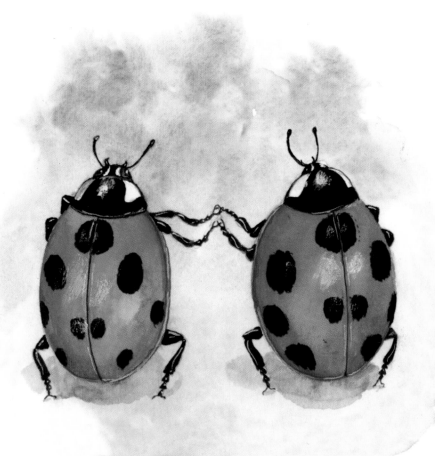

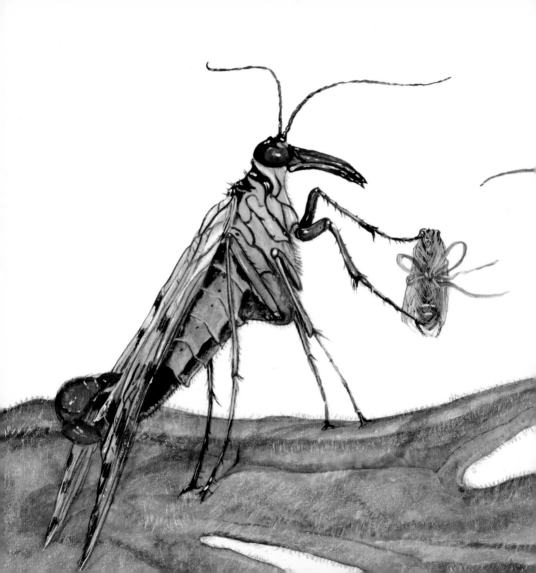

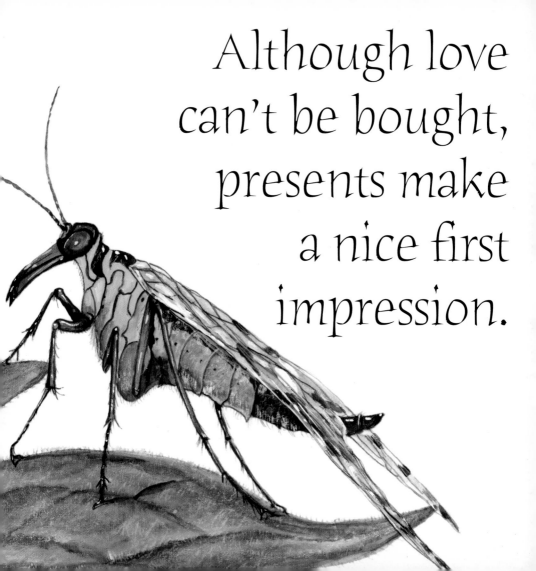

Although love can't be bought, presents make a nice first impression.

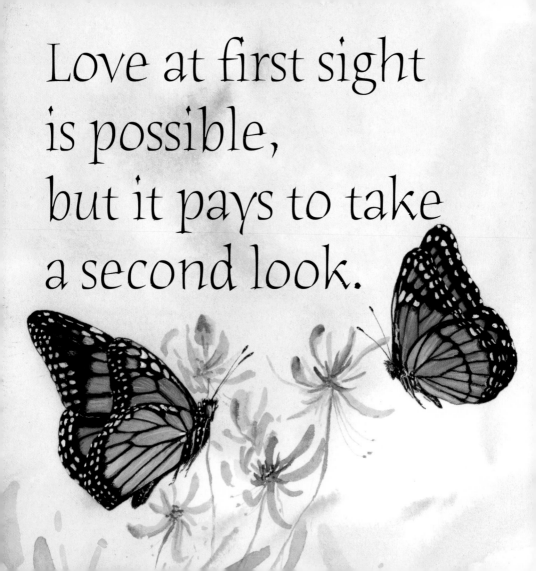

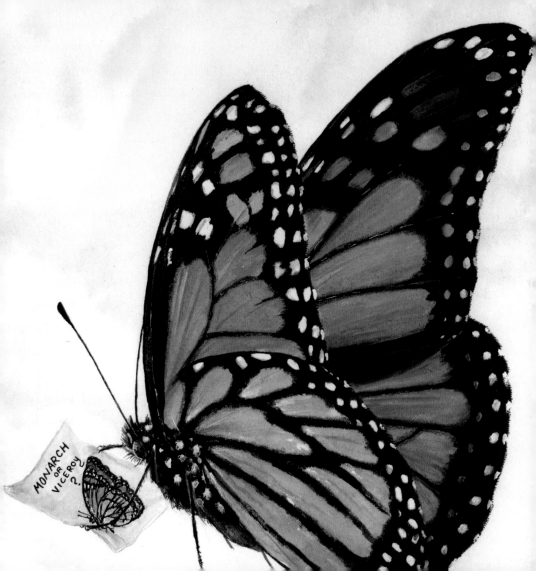

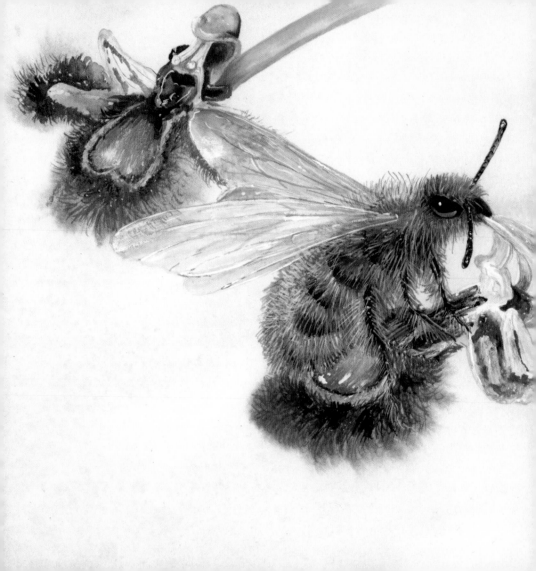

Sometimes
love can be a case
of mistaken
identity.

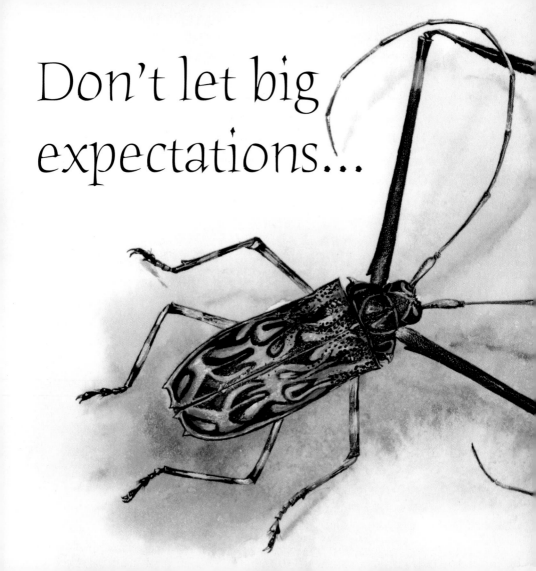

Don't let big
expectations...

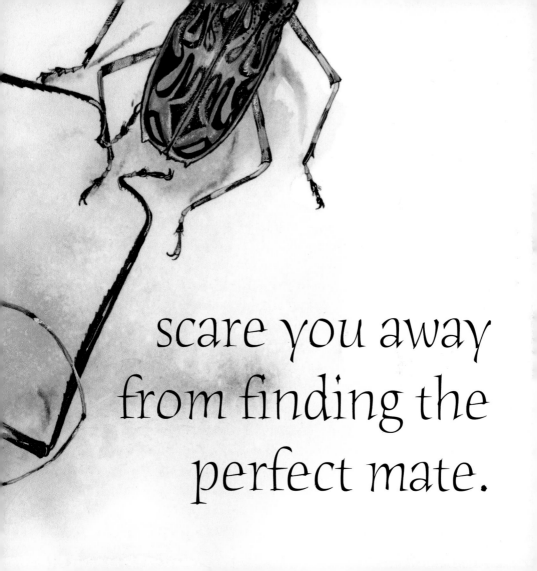

scare you away
from finding the
perfect mate.

A little spark
can kindle
a great fire!

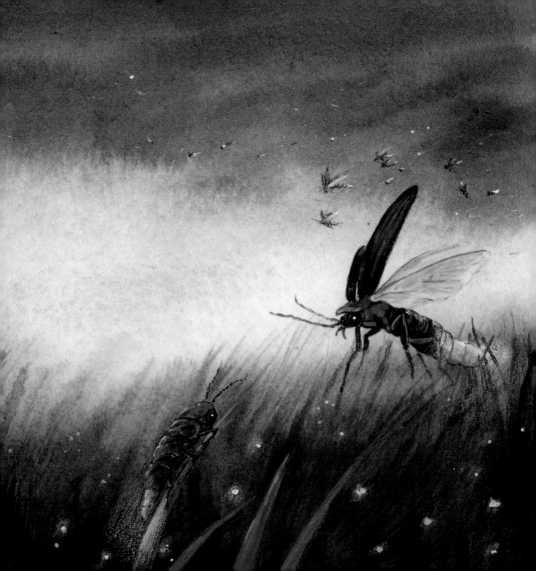

Starting
a relationship
requires
sticking your
neck out.

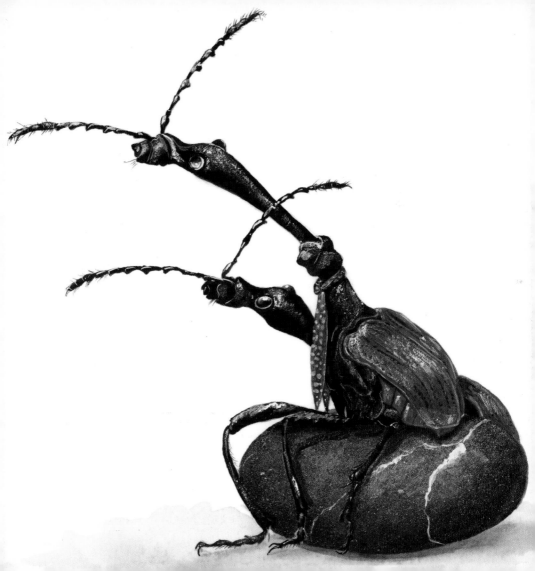

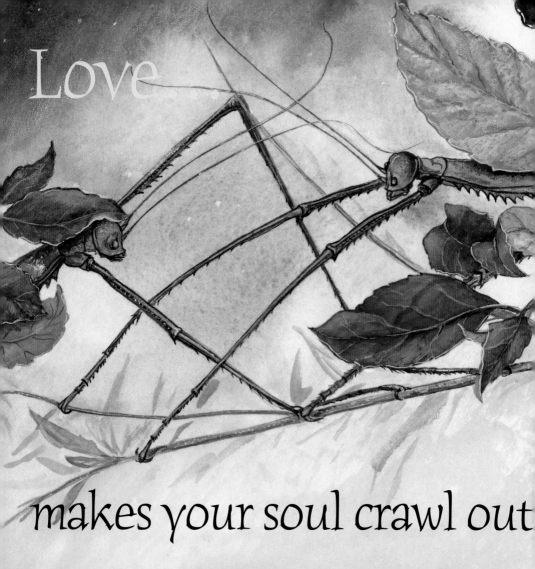

Love...

makes your soul crawl out

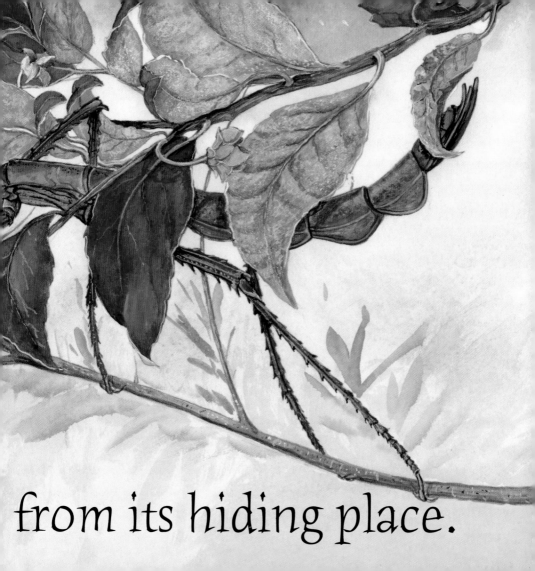

from its hiding place.

A perfect mate measures you by who you are, not by who she wants you to be.

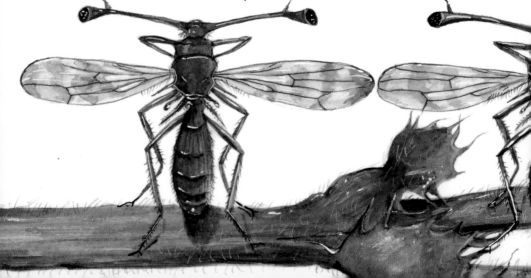

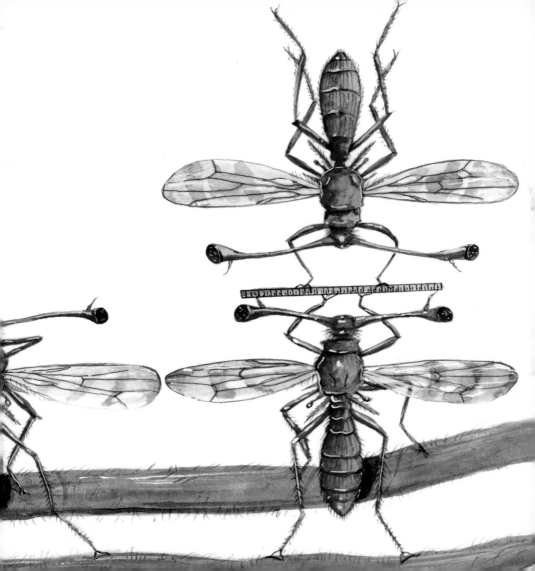

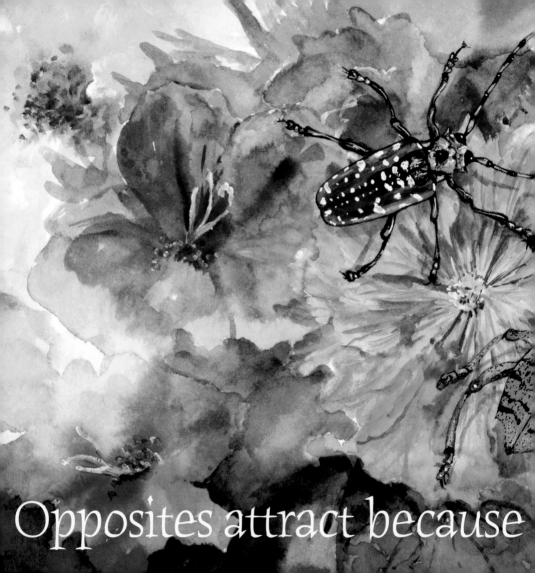

Opposites attract because

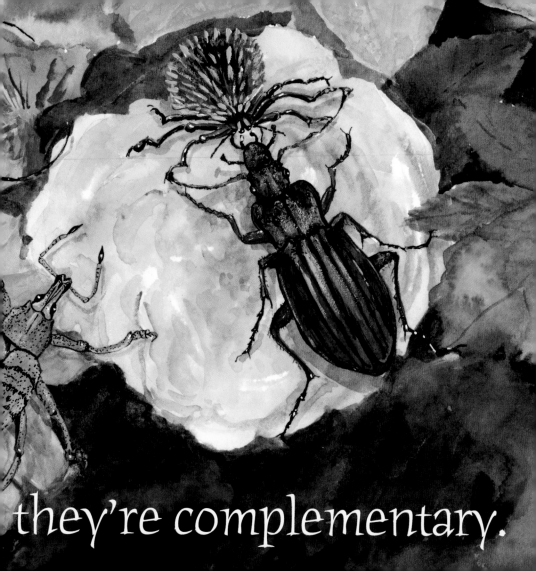

they're complementary.

Even a beetle
becomes a butterfly...

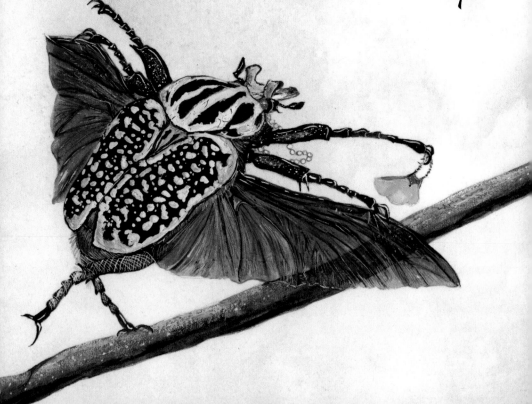

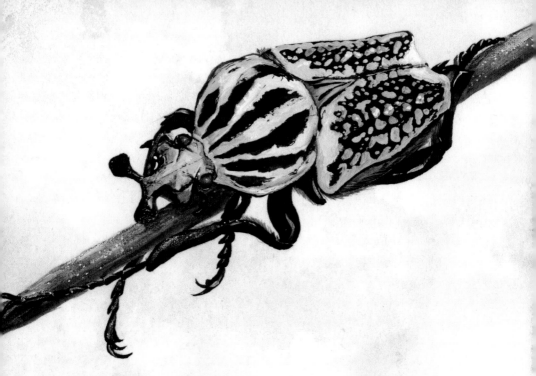

in the eyes of its
beholder.

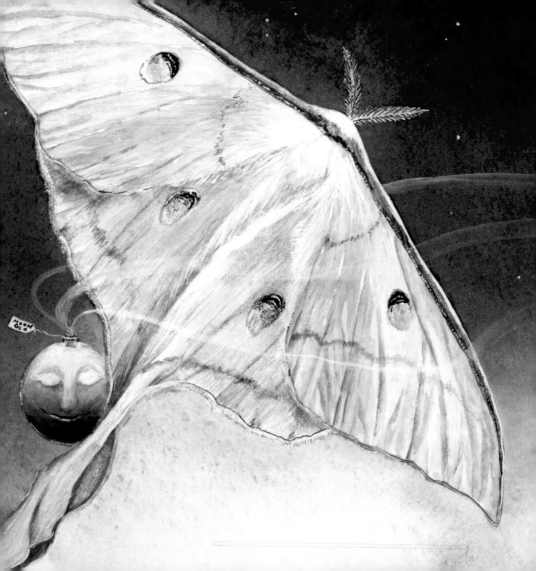

Love is an irresistible desire to be irresistibly desired.

Love,
like smiles,
can be
contagious.

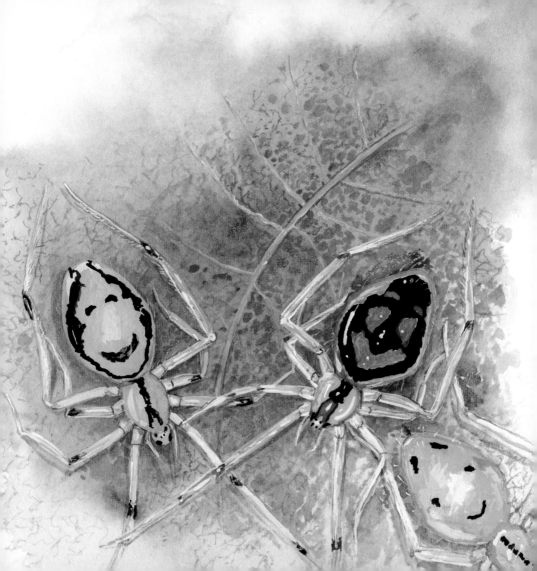

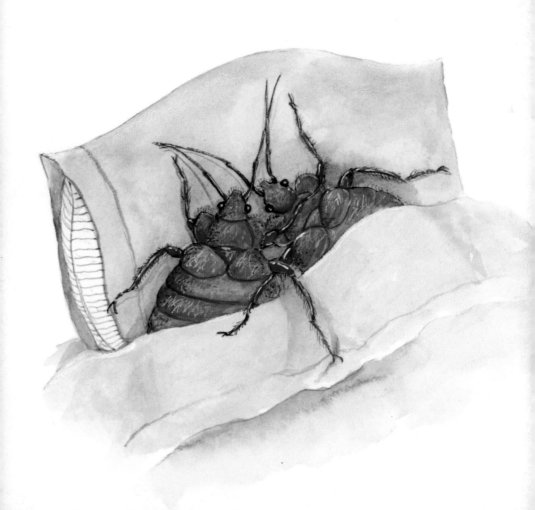

Finding the one
you love
makes you feel as
snug as a bug.

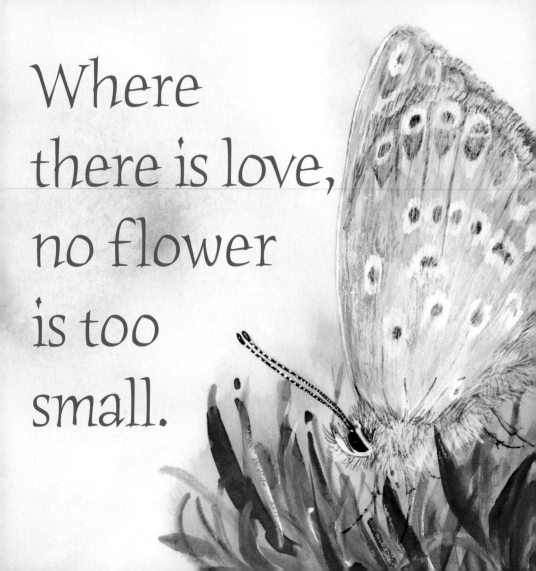

Where there is love, no flower is too small.

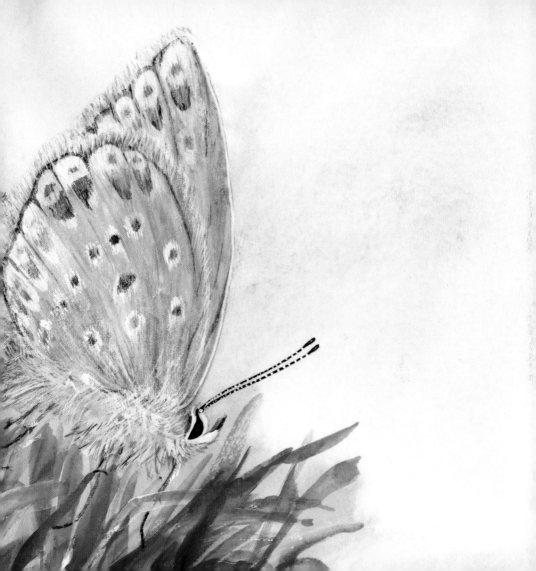

Love doesn't dominate.

It cultivates.

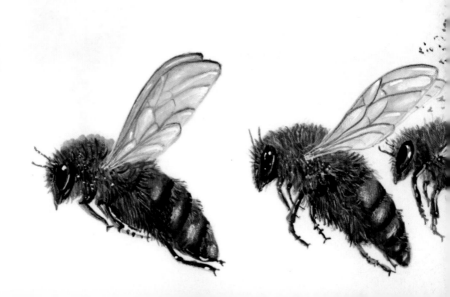

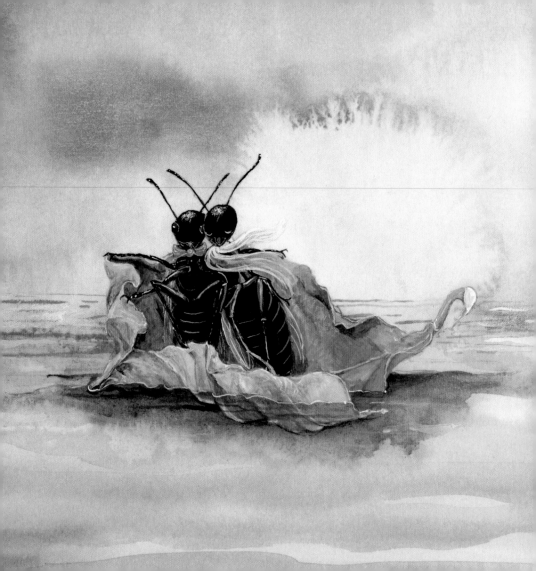

When love floats
freely,
it never sails
away.

Love is
shown in your
deeds,
not in your
words.

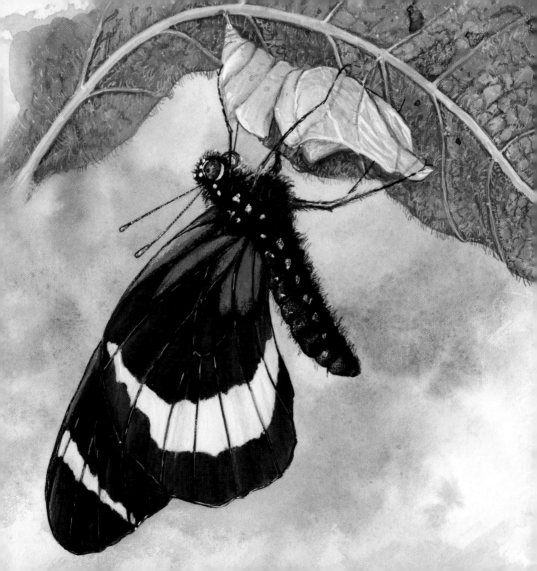

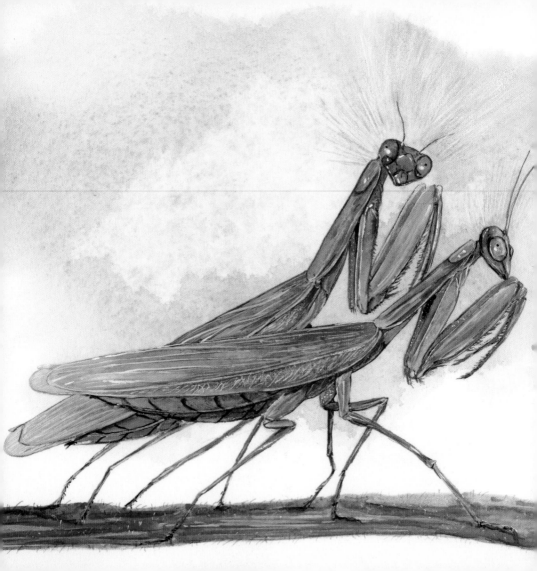

Couples in love
can tell each other
a thousand
things without
talking.

Romance rarely dies

but

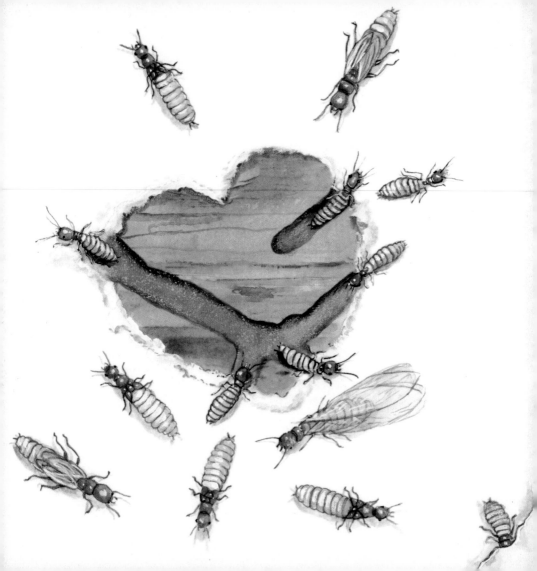

Assumptions
are the termites of
relationships.

Never look for
a worm
in the apple of
your eye.

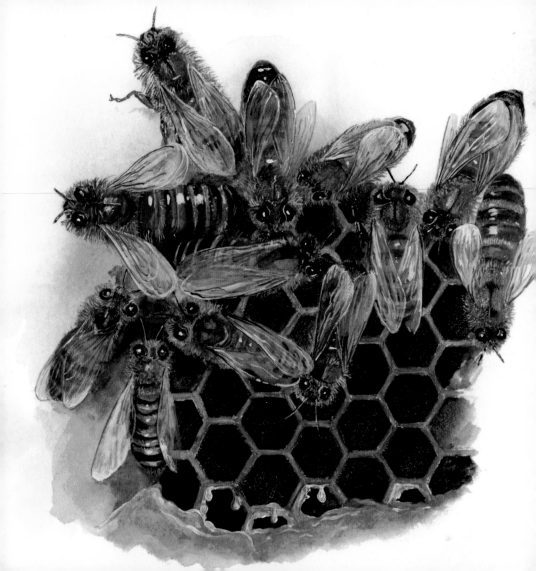

A happy
relationship is
an edifice that
must be rebuilt
every day.

Love
doesn't make
the world
go 'round;
it makes the ride...

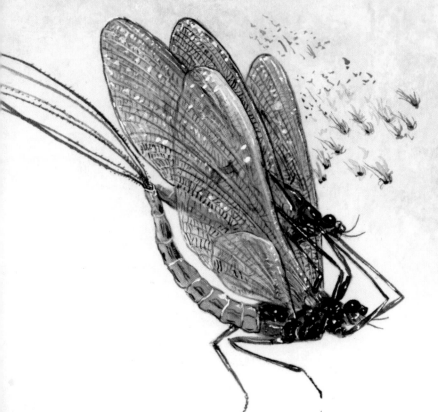

worthwhile!

About the Bugs

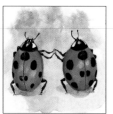

Ladybird Beetles (cover) *Coccinella novemnotata*
Ladybird beetles, also known as ladybugs, have long been regarded as the gardener's best friend because they eat plant-destroying aphids. Their common name of ladybird evolved during the Middle Ages in honor of the Virgin Mary, "Our Lady," when farmers observed that these insects rid crops and grapevines of destructive insect pests. The nine-spotted ladybird species is indigenous to the United States and Europe, but its numbers have greatly declined in recent years due to the introduction of the Asian ladybird. Asian ladybirds are voracious eaters and outcompete other ladybird species for food. Their "good bug" status is changing due in part to their habit of swarming indoors during cold winter months, and because they are known to feed on fruits such as grapes.

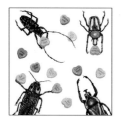

Bugs and Hearts (end papers)
In the insect world, the language of love is as varied as it is for humankind. Some insects bring gifts or serenade their mates; others perform flashy dances or compete with rival suitors to be chosen as the "one and only" by their prospective mates.

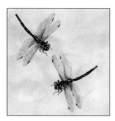

Dragonflies (title pages) *Aeshna cyanea*
Despite their name, dragonflies are not related to common flies. Members of the *Odonata* order of insects, dragonflies and damselflies include more than five thousand individual species and inhabit every continent of the world except Antarctica. Dragonflies spend most of their lives in the larva stage. The winged adult stage lasts for only a few weeks when they are ready to mate. The male generally establishes territory over a stream or pond and patrols it for most of the day, chasing other males away while he waits for females to fly by. When he spots an attractive female, he swoops down on her, and if she's interested, they perform a daring feat of aerial mating.

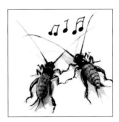

Crickets *Gryllus assimilis*

Each species of cricket has a characteristic song that's produced by the sounds of their front wings rubbing together in varying rhythms. In most species, only the males "sing," or stridulate. There are four types of cricket song, but all relate to courtship and mating. The calling song attracts females and repels other males, and is fairly loud. The courting song is used when a female cricket is near, and is very quiet. A louder, aggressive warning song is used when another male is detected nearby. And a softer, brief mating song is produced after a male has successfully deposited his sperm on the female's eggs. Female crickets can be identified by a spikelike appendage, called an ovipositor, on the hind end of their abdomens.

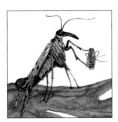

Scorpionflies *Panorpa vulgaris*

When a male scorpionfly wants to impress a female, he presents her with a prenuptial gift of food—another insect that has been ensnared by a spider's web and is wrapped in spider silk. If the gift is rejected, the female flies away. If the gift is accepted, she consumes the offering while mating with the lucky male. For scorpionflies, the way to a *woman's* heart is through her stomach!

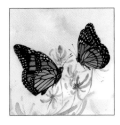

Monarch and Viceroy Butterflies *Danaus plexippus* and *Limenitis archippus*

Though these two species have almost identical markings, the viceroy butterfly is quite tasty to predators, while the monarch is unpalatable. Hence the viceroy's markings mimic those of the monarch for safety. When a male monarch goes in search of a mate, he looks for the difference in markings on the hind wings of a potential female mate. If there is no black semicircle on the female's hind wings, she's a monarch to be courted. The males then release a special hormone attractive to females from tiny clusters of hairs on their abdomens. Both monarchs and viceroys are found throughout North America, but monarchs are also found in New Zealand, Australia, the Canary Islands, the Azores, and Madeira.

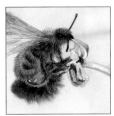

Orchid Scoliid Wasp *Dasyscolia ciliata*

Found throughout the Mediterranean, ophrys orchids (*Ophrys ciliata*) emit optical and olfactory stimuli to attract male scoliid wasps looking to mate. The flower of this orchid mimics the top of the female insect's abdomen: blue iridescent wings folded over a hairy body. It also emits a stimulating scent compound attractive to the wasp. Although this is a case of mistaken identity for the wasp, it's a successful case of pollination for the flower.

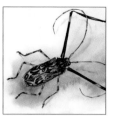

Longhorn Harlequin Beetle *Acrocinus longimanus*

These large beetles thrive throughout the tropical forests of Central and South America. The males have extralong front legs and antennae that look like horns. In addition to serving as a sexual advertisement to females, the long legs help the males to traverse the branches of trees (the beetles fly as well as crawl). Female harlequin beetles are highly selective in choosing only recently dead or dying trees in which to deposit their eggs. A female harlequin beetle will mate only with a male who can monopolize suitable egg sites by outcompeting other male beetles for the best sites.

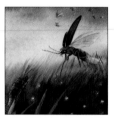

Fireflies *genus Photinus*

Fireflies are winged beetles known for their conspicuous use of bioluminescence to attract mates or prey. Their unique courtship behavior is distinguished by the flashing patterns emitted by flying males in search of females. Different species of fireflies recognize each other by their flashing signals at different times of evening or night. Females generally do not fly, but do give a flash response to males of their own species. If a flashing male catches a female's fancy, a short flashing "dialogue" may ensue between the two as the male locates the female's position and descends to mate. Female fireflies have been known to prefer certain characteristics of a male's flashing signal (such as increased flash rate) and respond to males that best demonstrate these "sexy" signals.

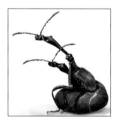

Madagascar Giraffe Beetle *Trachelophorus giraffa*

The giraffe beetle is native to the island of Madagascar. Its common name comes from its long, extended neck, much like that of a giraffe. Male giraffe beetles have necks two to three times longer than females; this evolutionary feature assists the males in nest building prior to mating. As part of their courtship behavior, a male giraffe beetle uses his long neck to roll and secure a leaf-tube nest. He then mates with the female, who lays a single egg within the leaf tube.

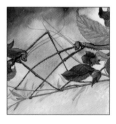

Walking Stick *Phobaeticus serratipes*

One of the approximately three thousand stick insect varieties in the world, the 13-inch-long (33 cm) Southeast Asian walking stick is the longest of all insects. Walking sticks blend into their surroundings, hanging motionless from leaves and branches to fool hungry predators until dark, when they are ready to feed. Their stemlike bodies and muted colors make them almost invisible among the foliage of the plants that they prefer as food. Unlike most insects, female walking sticks can reproduce nonsexually, causing some offspring populations to be entirely female. When there *are* males present, females attract mates by emitting a seductive pheromone, and the couple will then mate while clinging to a twig or leaf.

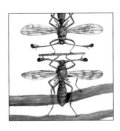

Stalk-Eyed Flies *Teleopsis dalmanni*

As their common name suggests, stalk-eyed flies have a unique eye feature: eyes and antennae at the ends of long eyestalks. The male flies are able to take air in through their mouths and pump it through ducts in their heads to the tips of the stalks, which further elongates their eyestalks. This is prevalent especially in mating season. Females show a strong preference for males with longer eyestalks, and males compete with each other in a ritualized contest that involves facing each other and comparing their relative eye spans, often with the front legs spread out to add emphasis.

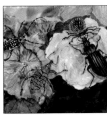

Beetles and Flowers (Left to right, top: *Calloplophora solli, Julodis hiritiventris sanguinipilig;* bottom: *Eupholus* and *Chrysocarabus auronitens*)

Flowers provide various kinds of food for beetles of all species, but they are also an important meeting place of the sexes—a kind of insect discotheque!

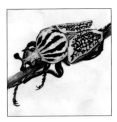

Goliath Beetles *Goliathus regius*

Goliath beetles are among the largest insects on earth, if measured in terms of size, bulk, and weight. Adults measure from almost 2 1/2 to a little over 4 inches (60–110 mm) in length, and can reach weights of almost 3 to 3 1/2 ounces (80–100 g) in the larval stage, although the adults are only about half this weight. Native to the tropical rain forests of Africa, goliath beetles have an excellent sense of smell and eyesight. They have scent detectors on both their eyes and their antennae, which they use to hunt for food and for detecting mates, and they sport two pairs of wings. The first pair are protective coverings for the secondary pair of wings; only this pair is actually used for flying.

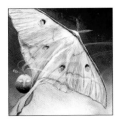

Moon Moth *Actias selene*

When the female moon moth is ready to mate, she releases pheromones into the night air that can be detected by an interested male several miles away. Thanks to the male's antennae, he can find his companion at this distance by simply following her perfumed emissions. The moth is named after the moon because of its exquisitely soft, diaphanous green color. It belongs to the *Attacidae* family of moths, which are notable for hind wings that extend into long tails. This moth flies mainly at night and is quite widespread throughout Asia.

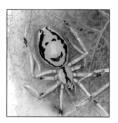

Happyface Spiders *Theridion grallator*

Native only to the Hawaiian Islands, tiny happyface spiders sport a variety of body colors and distinctive facelike markings. Many are happy-faced, while some appear to be frowning, and others resemble "aliens." Inhabitants of the lush tropical forests of Hawaii, the females are largely sedentary, while the males tend to move about more in search of mates. This makes the males more vulnerable to predators such as birds. As a consequence of natural selection, females tend to prefer mates that have rare coloration and markings, because they are less likely to be attractive or recognizable to predators.

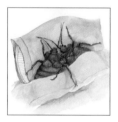

Bedbugs *Cimex lectularius*

Bedbugs are tiny, elusive, parasitic insects found in temperate climates throughout the world. They live by feeding on the blood of humans and other warm-blooded animals. Although not strictly nocturnal, bedbugs have an aversion to sunlight and are active mainly at night, often feeding unnoticed by their hosts. Although highly undesirable to humans, bedbugs make themselves at home in the snug, warm confines of houses, especially in beds or other common areas where people may sleep.

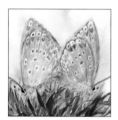

Common Blue Butterflies *Polyommatus icarus*

Like most butterflies, common blues are most active in sunshine and gravitate to flowers to feed on nectar and lay their eggs. The courtship of common blue butterflies involves colorful wing displays and scent emissions to attract potential mates. The upper sides of the wings of the male are bright blue, while the female's wings are primarily light brown. Males establish territories, which they patrol in search of females. When females are present, they flash their brightly colored wings and release a scent that is picked up by the mate's antennae. When egg-laying, the female makes slow flights searching out suitable food plants on which to lay. Common blues are found throughout the British Isles, with the exception of Ireland.

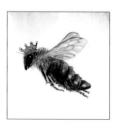

Honeybees *Apis mellifera*

A virgin honeybee queen sometimes makes a few exploratory flights from her hive when she is three to five days old, before making her nuptial flight. Occasionally, a queen will return mated within a few minutes, but usually she is away between ten and thirty minutes. When a virgin queen sails forth, she is usually followed by a large number of drones, and with these in pursuit, she flies very rapidly so that she is overtaken only by the strongest, thus ensuring vigor in her offspring. A strange fact concerning the mating of the queen is that the drone usually dies immediately after mating, and the queen returns to the hive with the male sex organs still clinging to her. These are either pulled away in time by the workers, or they simply dry up and fall off.

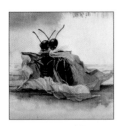

Black Ants *Lasius niger*

The most commonly seen black ants are sterile, wingless female workers foraging for food as they crawl to and from their colonies. When black ants are ready to mate, they grow wings and commence a mass mating flight containing thousands of males and females from different colonies. After mating, males and queens shed their wings. The queens land and begin searching for suitable places to dig tunnels in which to lay their eggs to establish new colonies. Meanwhile, the males generally live for only a day or two after the flight and die. The mating flight ensures that the species disperses well, and also increases the chance that males and females from different nests will mate, avoiding inbreeding.

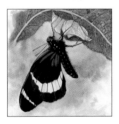

Heliconius Butterfly and Pupa *Heliconius hewitsoni*

This boldly patterned butterfly is found throughout Panama and the Pacific slopes of Costa Rica. Male heliconius butterflies reach adulthood before females and engage in what is known as "pupal mating." While a female is still in her pupal stage, males visit her and compete with each other to claim and guard the female chrysalis, waiting for her to become sexually receptive just before she emerges from her pupa. As the females begin to metamorphose, mating occurs when one male is able to clasp the female as she emerges. Mating may last thirty minutes to several hours, during which time the male does not feed and continues to ward off competing males by flashing his wings.

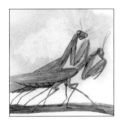

Praying Mantis *Mantis religiosa*

The soundless courtship ritual of the praying mantis is an interesting and sometimes lethal affair. Most of the time, the male mantis slowly approaches the female face to face, and the couple performs an elaborate ritual dance, stroking each other's antennae, until the female's final pose motions that she is ready to mate. A second form of courtship is less amorous: the male approaches the female from behind with stealth and quickly tries to jump on her back. If the female notices him beforehand, she treats him as prey and sets about devouring him! If the male's approach is successful, he maintains a secure hold on the female's wings with his middle and hind legs, and strokes her antennae with his own to arouse her in order to mate.

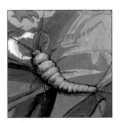

Silverfish *Lepisma saccharina*

Silverfish are considered household pests by humans due to their consumption of any substance containing starches, such as book bindings, paper, food, hair, carpet, clothing, and fabrics. They are silvery in color, have long antennae, and move in a wiggling motion that resembles that of a fish. When silverfish are ready to mate, they perform a three-phase ritual. In the first phase, the couple face each other, their trembling antennae touching, then repeatedly back off and return to this position. In the second phase, the male runs away and the female chases him. In the third phase, the couple stand side by side, with the male vibrating his tail against the female. Finally, he lays a sperm capsule that the female takes into her body to fertilize her eggs.

Subterranean Termites *Reticulitermes hageni*

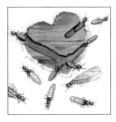

Termites live in colonies that, at maturity, number from several hundred to several million individuals. A typical colony contains nymphs (semimature young), workers, soldiers, and reproductive individuals of both genders, sometimes including several egg-laying queens.

The workers, which are about 1/8 inch long, have no wings, are white to cream in color, and are very numerous. Soldiers defend the colony against insects such as ants; also wingless, and white in color, they have large brown heads and jaws. King and queen termites perform the reproductive functions of the colony. They are dark brown to black in color and have two pairs of wings about twice the length of their body. Winged kings and queens emerge from colonies and take flight in great numbers, usually in the spring. Mating occurs during these flights, and males and females form new colonies.

Humans commonly consider termites to be pests because they can cause serious structural damage to buildings, crops, and plantation forests. But in nature, termites consume large quantities of decomposing organic matter, particularly in subtropical and tropical regions, and their recycling of wood and other plant material is of considerable ecological importance.

Winter Moth Caterpillars *Operophtera brumata*

The winter moth, found throughout Europe and the Near East, is one of the few species of temperate-region moths in which the adults are active during the winter. Female winter moths have small, nonfunctioning wings, but the male is fully winged and a strong flier. After mating, females lay their eggs in tree-bark crevices. The eggs hatch in the spring, and the young caterpillars crawl up the tree trunks and produce silken threads that can carry them in the wind to new locations. This dispersal method, called "ballooning," is common among insects that feed on vegetation. Winter moth caterpillars will feed on virtually any tree or plant and can be a serious pest in apple orchards.

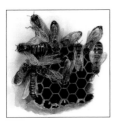

Honeybee Colony *Apis mellifera*

Over the centuries, honey has been a symbol of a sweet and fruitful life in love and marriage. Honey has been used at weddings for thousands of years. In India, bridegrooms receive honey to ward off evil spirits. In Croatia, it has been the custom to smear the threshold with honey as a new bride enters the groom's house.

This "fruit" of the labor of honeybees is produced inside a remarkable structure that is also the product of perfect social cooperation. A honeycomb is a mass of hexagonal wax cells built by honeybees in their nests to contain their larvae and stores of honey and pollen. Honeybees know a thing or two about working with wax and fashioning elegant, symmetrical structures. While gorging themselves on honey, young worker bees slowly excrete slivers of wax, each fleck about the size of a pinhead. Other workers harvest these tiny wax scales, then carefully position and mold them to assemble a vertical comb of six-sided, or hexagonal, cells. The bees cluster in large numbers and fan the structure with their wings, maintaining a hive temperature of 95°F (35°C), which keeps the wax firm but malleable during cell construction. This energetic piecemeal activity produces a strong, remarkably precise structure. Charles Darwin described the honeycomb as a masterpiece of engineering that is "absolutely perfect in economising labour and wax."

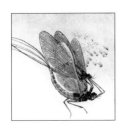

Common Mayflies *Ephemera vulgata*

Adult mayflies live short but exhilarating lives! When they begin their courtship, the males fly together in swarms at dawn or dusk and the females approach the swarm ready to mate. In what resembles a winged dance, a male then approaches a female from behind and flies under her, initially grasping her behind the head at the wing root with his unusually long forelegs. Mating lasts only about twenty seconds, as the pair lose altitude and then separate before reaching the ground. It often happens that all the mayflies in a population mature at once, and for a day or two in the spring or fall, mayflies will be everywhere, dancing around each other in large groups or resting on every available surface. They are aquatic insects whose immature stage as nymphs usually lasts for a year in freshwater. But the life span of an adult mayfly can vary from just thirty minutes to one day, depending on the species. As with most other insects, the primary function of the adult is reproduction.

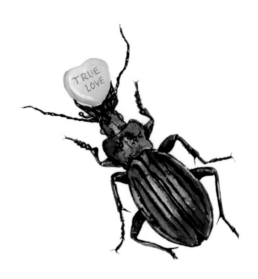

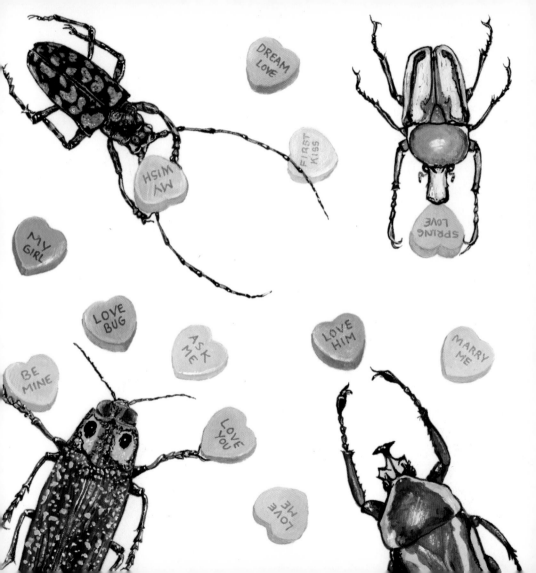

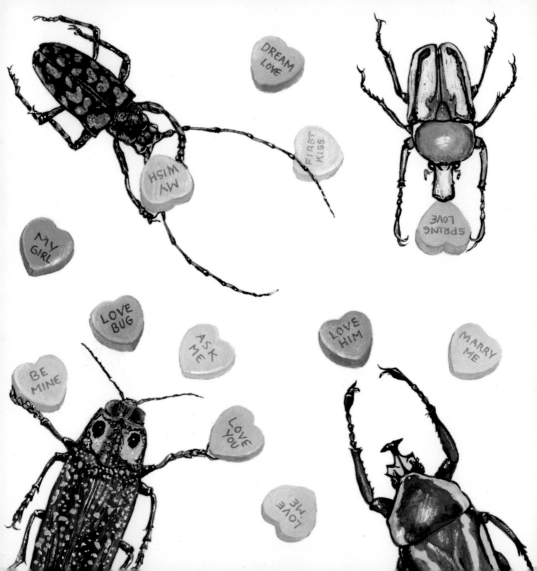